The Top 9+1 North America Destinations for family and Co.

Everything you need to know to travel North America on a Budget with your family and make your dream holiday become reality in 2021.

BY

The lost Traveler.

Disclaimer and Terms of Use:

Effort has been made to ensure that the information in this book is accurate and complete, however, the author and the publisher do not warrant the accuracy of the information, text and graphics contained within the book due to the rapidly changing nature of science, research, known and unknown facts and internet.

The Author and the publisher do not hold any responsibility for errors, omissions or contrary interpretation of the subject matter herein. This book is presented solely for motivational and informational purposes only.

THE LOST TRAVELER

"Traveler for 365 Days"

The Lost
TRAVELER

For over 80 years, "The Lost Traveler" has been a trusted resource offering expert travel advice for every stage of a traveler's journey. We hire local writers who know their destinations better than anyone, allowing us to provide the best travel advice for all tastes and budgets in over 7,500 destinations around the world. Our books make it possible for every trip to be the trip of a lifetime.

Our mission is to make every country accessible for any type of wallet and family.

Our key phrase is: *"If you haven't toured the world at least once, it's as if you've never really known the place where humanity has always lived"*

Contents

America

The USA is one of those countries which is third most visited country on the planet. Yet, we are specific, and numerous individuals are pondering, "for what reason would you like to go to the USA?" Even though it seems like everybody has a deep understanding of the United States of America, it's as yet a country that will shock you once you initially go there. Merely attempting to find out about it is a valid justification for visiting. There are all kinds of fun exercises, numerous delightful scenes and various societies living respectively. It's a gigantic country,

and you should go more than once if you genuinely need to have the entire American experience. Anyway, we can promise you, visiting the States won't be exhausting by any means. The nation is very decidedly ready for the vacationers. Everywhere in the country, you will see there is a great deal of security. It very well may be somewhat exhausting now and then, however toward the end, it is ideal. That way, you can be looser and not all the time thinking about the case you're protected or not. The administrations are likewise extraordinary, regardless of if it's extravagance or modest travel. They will consistently treat you very well at inns,

cafés. But in any case, on the off chance that you don't care to set up the excursion without anyone else, you could generally do it with an office, which, there are thousands that arrangement outings to the States.

1. Wailea, Hawaii

What is the best North American island get-away? Indeed, it's a city so pleasant, you picked it twice. Wailea, clearly, is never the bridesmaid, consistently the lady. Favored with five shocking bow formed sea shores, richly in vogue resorts, and close by Ahihi-Kinau Normal Region Save, this location spoils voyagers' faculties with a-list food, delightful sights, new sea aromas, and welcoming climate.

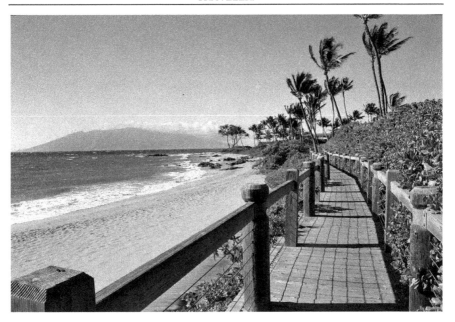

2. Cambria, California

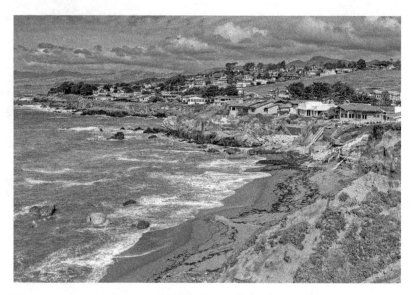

Sitting on seemingly the prettiest stretch of waterfront land in California, Cambria is an untainted little town among massive excellence. Reflecting such merits, it bounced from No. 6 to No. 2 this year. Walk the Moonstone Sea shore Footpath to spot ocean life, or take a horseback visit through the mountains with Covell's

California Clydesdales. Frequently filling in as headquarters for those venturing out to Hearst Mansion, Cambria has a lot charms to investigate!

3. Springdale, Utah

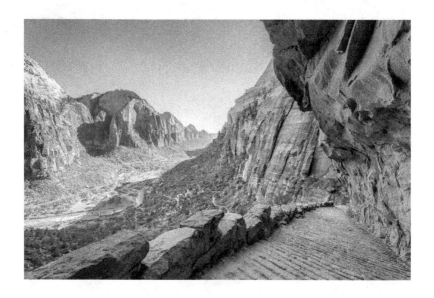

Remaining emphatically in the No. 3 spot, Springdale draws in guests who like experience, excellence, and nature. This is the spot to remain while investigating Zion Public Park to see the becoming flushed tons of sandstone precipices. The town is a top pick for its

town like appeal, southern Utah scene, and well-disposed local area.

4. Ashland, Oregon

In nearness to the Rebel Waterway — and facilitating top notch theater and the amazing Shakespeare Celebration — Ashland advances to craftsmanship sweethearts and open air lovers the same. Balance a day of trail running, stream boating, or skiing with asparagus dumpling soup or smoked brisket with stew sauce at Child. Or on the other hand, go through the day shopping neighborhood stores, at that point treat yourself to a loosening up night with the Rebel Valley Orchestra.

5. Sedona, Arizona

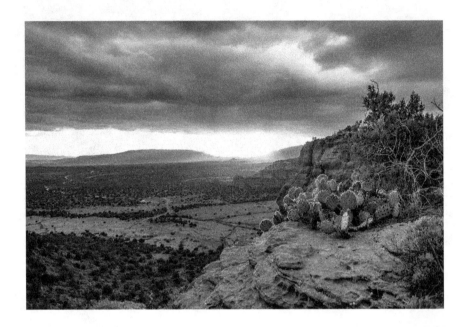

Sedona is an enchanted place, but it took no fairy dust to jet it up from No. 20 this year. With its outdoor beauty, calming retreats and spas, and highly walkable downtown, the appeal is undeniable. Unreal starry skies are the reason for a night hike on Baldwin Trailhead, and

Gallery Row is the spot for an afternoon of culture.

6. Cambridge, Massachusetts

A city of neighborhoods, Cambridge invites you to pick your favorite flavor. Harvard Square is the most compact and will be favored by book lovers, but Central Square packs a lot into a small space, and is an ideal area to explore the eclectic flavors of the city. Head to East Cambridge for hidden gems, or super-cute Inman Square for thrift shopping and beer sipping.

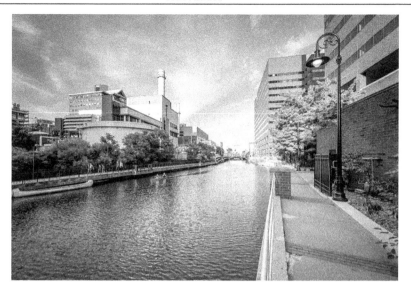

7. Minneapolis, Minnesota

Up two slots this year, Minneapolis rounds out our top 10 vacation spots in North America, and continues to gain popularity. Historically underestimated, this Minnesota city has been catching attention for its friendly people, international and regional foods (we'll take a Jucy Lucy, please), beautiful natural surroundings, and entertainment options. Sports enthusiasts will find plenty to love, as the city boasts five pro teams.

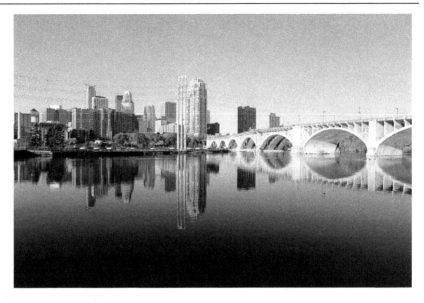

8. Paso Robles, California

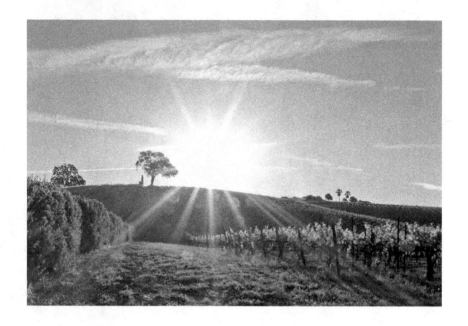

Generally known for wine, Paso Robles dominates at more than reds and whites. The region has seen an ascent in cideries, refineries, and breweries. Pair your ideal refreshment with a similarly extraordinary feast at diners in and out of town. Take your pick of flavors, from California coast-meets-Mexico at Fish

Gaucho to nearby joys at Thomas Slope Organics..

9. Solvang, California

This Danish town is encircled by activities. Wine sampling, horseback riding, theater going, climbing, cake snacking — the rundown is perpetual. Respect the engineering, windmills, and Little Mermaid form, and on the off chance that you love celebrations, come for occasions like Solvang Danish Days or Taste of Solvang.

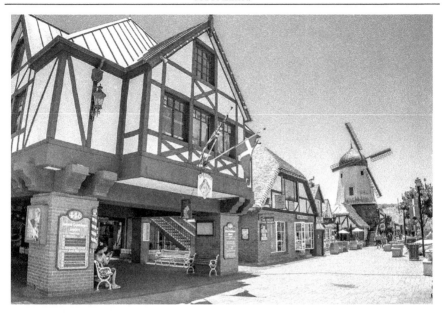

10. Bar Harbor, Maine

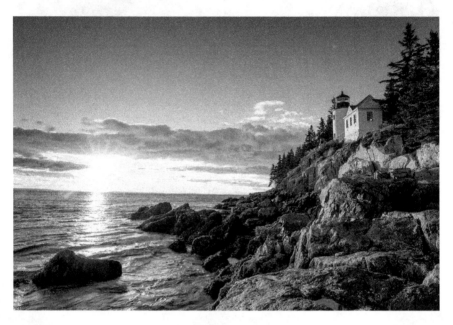

New to the Top 50 this year, Bar Harbor's lucky number is clearly 13. What could have catapulted the city onto the list of best places to vacation? Well, Cadillac Mountain and Acadia National Park might have a little something to do with it, but museums, lighthouses, breweries, and music festivals (to name a few), appeal to

curious visitors and keep them coming back.

11. Key West, Florida

Key West has been a perennial favorite and beloved vacation spot for its array of appealing attractions. SCUBA and snorkeling, famous bars like Sloppy Joe's, parks, ecotours, beaches, celebrated pie, and daily sunset festivals greet happy travelers. Warm winter temperatures keep it a go-to for escaping frosty weather.

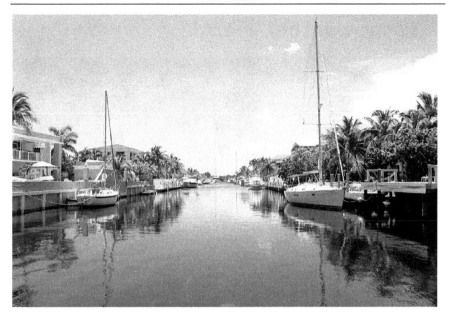

12. Sanibel, Florida

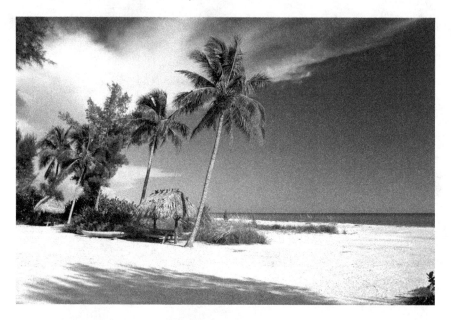

Not to be too outdone by its southerly state-mate, Sanibel clinches the No. 15 spot in its first appearance. Visitors fall in love with the place for many reasons. Go shelling on the beach, fill up on fresh seafood at joints like the super-fun Bubble Room, and spend peaceful time at J.N. Ding Darling National Wildlife Refuge.

13. Pittsburgh, Pennsylvania

Pittsburgh continues to rise in estimation, offering visitors gems like the Andy Warhol Museum, the Butterfly Garden at Phipps Conservatory, foodie tours, thrilling sports teams, and many remarkable neighborhoods to explore. As a riverfront city, Pittsburgh provides scenic paths, trails, and opportunities to get on the water. Who knew Pittsburgh was one of the best places to vacation? Our reviewers did!

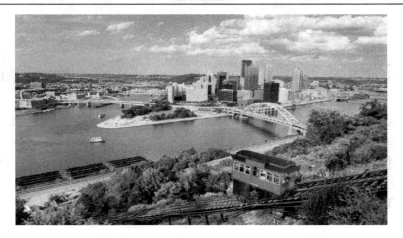

14. Washington, D.C.

Go to a walk or study the country's set of experiences — D.C. these days is perhaps the best spot to go for both. Come see the cherry blooms and dream of sunnier occasions. Or on the other hand look at the exuberant nightlife and let loose a little. Numerous free exhibition halls, remembrances, occasions, and exercises will fill your days without purging your pockets.

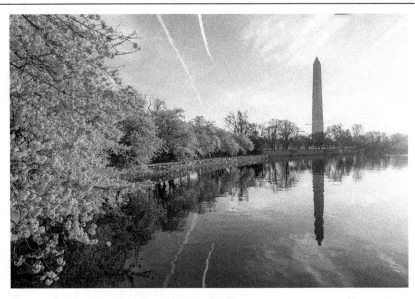

15. Charleston, South Carolina

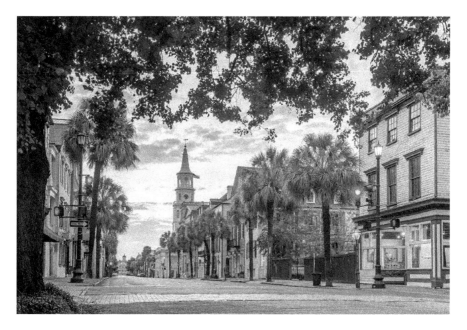

Charleston winds up on such countless top choices records, it ought to get its own image bargain. Workmanship, culture, entertainment, unwinding — this city dominates at each. Go on a mobile visit to take everything in, or pick from five territory sea shores to investigate. Food is a significant feature of city culture, and

South Carolina has the merchandise, so come hungry.

16. Rosemont, Illinois

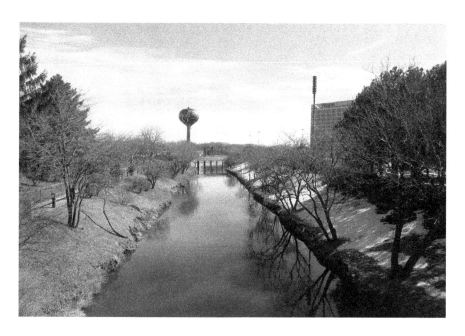

Travelers love to stay in Rosemont, a welcoming village just outside of Chicago. Jumping two spots this year, it continues to be a high-rated location. Maybe it's the friendly residents, maybe enthusiastic Wolves fans are casting their votes, or maybe it's just the perfect place to escape

city crowds. Whatever the reason, people are crushing on Rosemont.

17. Durango, Colorado

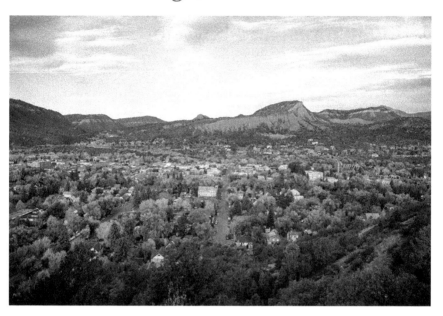

Up from the 40th slot last year, Durango impressed 2017 travelers with awe-inspiring nature, laid-back locals, Old West vibes, and plenty of cultural pursuits. Visit one of the many galleries or museums, like the Animas Museum, which highlights Durango history. The outdoors tempts explorers with all the

things to see and do in the San Juan National Forest and beyond.

18. Kihei, Hawaii

Hawaiian eminence of yesteryear decided to relax in Kihei, and with its radiant climate and lovely sea shore sees, you realize those royals had the correct thought. The typical beachy suspects — swimming, swimming, surfing — sparkle a little more splendid in this southern Maui city, and come winter, you may detect a humpback whale from shore.

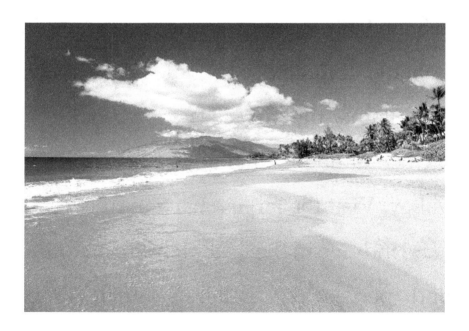

19. Lahaina, Hawaii

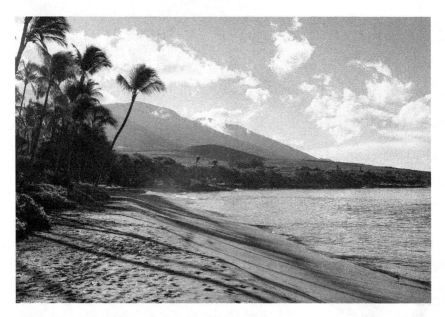

Life is truly rainbows and sunbeams in Lahaina. Situated near the West Maui mountains, the city sees a near-daily "5 o'clock rainbow" that stretches across the valley. Visit the largest banyan tree in the U.S., indulge in the best nightlife on Maui, and peruse the galleries along Front

Street; your time in Lahaina can be as eclectic as the rainbows are colorful.

20. Lihue, Hawaii

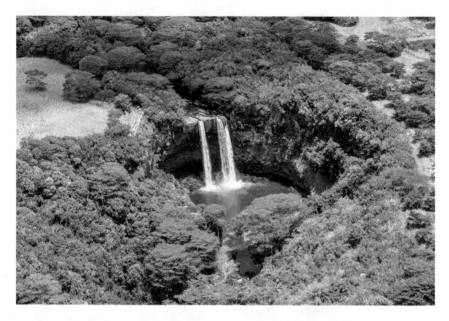

The Hawaii love-fest continues for Lihue. Perhaps the nectars at Koloa Rum Company have magical properties, or the beauty of Wailua Falls casts a potent spell; whatever sorcery graces Lihue, we're all in. If you can tear yourself away from the beach, go to the Kauai Museum to learn

about the history and formation of this bewitching island.

21. Chicago, Illinois

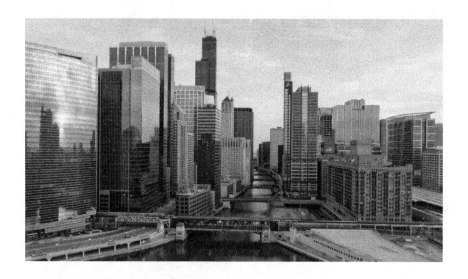

Chicago's history is closely tied to its proximity to Lake Michigan. While the Chicago River historically handled much of the region's waterborne cargo, today's huge lake freighters use the city's Lake Calumet Harbor on the South Side. The lake also provides another positive effect: moderating Chicago's climate, making

waterfront neighborhoods slightly warmer in winter and cooler in summer.

22. Asheville, North Carolina

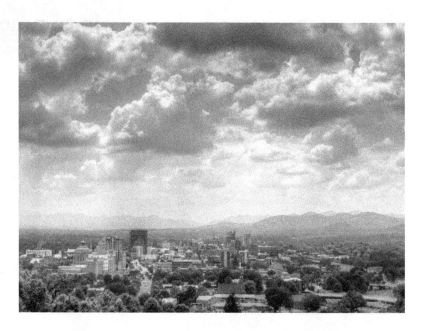

Asheville is a major hub of whitewater recreation, particularly whitewater kayaking, in the eastern US. Many kayak manufacturers have their bases of operation in the Asheville area. Some of the most distinguished whitewater kayakers live in or around Asheville. In its

July/August 2006 journal, the group American Whitewater named Asheville one of the top five US whitewater cities. Asheville is also home to numerous Disc Golf courses. Soccer is another popular recreational sport in Asheville. There are two youth soccer clubs in Asheville, Asheville Shield Football Club and HFC. The Asheville Hockey League provides opportunities for youth and adult inline hockey at an outdoor rink at Carrier Park. The rink is open to the public and pick-up hockey is also available. The Asheville Civic Center

has held recreational ice hockey leagues in the past.

23. Moab, Utah

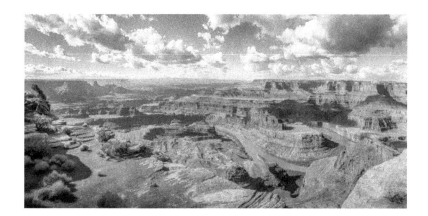

Since the 1970s, tourism has played an increasing role in the local economy. Partly due to the John Ford movies, partly due to magazine articles, the area has become a favorite of photographers, rafters, hikers, rock climbers, and most recently mountain bikers. Moab is also an increasingly popular destination for four-wheelers as well

as for BASE jumpers and those rigging highlining, who are allowed to practice their sport in the area. About 16 miles (26 km) south of Moab is Hole N" The Rock, a 5,000-square-foot (460 m²) 14-room home carved into a rock wall which *National Geographic* has ranked as one of the top 10 roadside attractions in the United States. Moab's population swells temporarily in the spring and summer months with the arrival of numerous people employed seasonally in the outdoor recreation and tourism industries.

24. Seattle, Washington

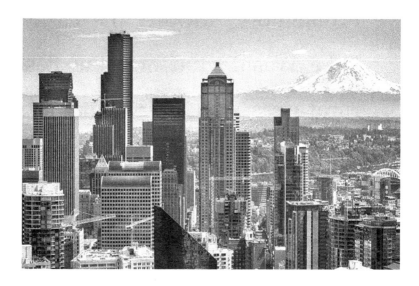

Seattle is situated between the saltwater Puget Sound (an arm of the Pacific Sea) toward the west and Lake Washington toward the east. The city's central harbor, Elliott Inlet, is essential for Puget Sound, which makes the city a maritime port. Toward the west, past Puget Sound, are the Kitsap Landmass and

Olympic Mountains on the Olympic Promontory; toward the east, past Lake Washington and the Eastside rural areas, are Lake Sammamish and the Course Reach. Lake Washington's waters stream to Puget Sound through the Lake Washington Boat Channel (comprising of two man-made trenches, Lake Association, and the Hiram M. Chittenden Locks at Salmon Cove, finishing off with Shilshole Straight on Puget Sound).

25. Chandler, Arizona

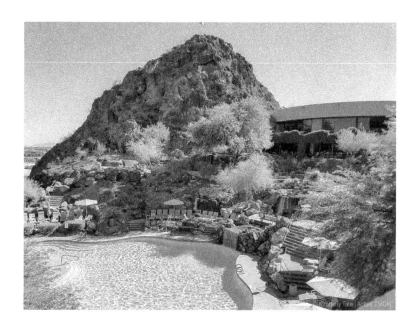

There are numerous properties in the town of Chandler which are considered to be historical and have been included either in the National Register of Historic Places or listed as such by the Chandler Historical Society. The Historic McCullough-

Price House, a 1938 Pueblo Revival-style home, was donated to the city by the Price-Propstra family in 2001. The city renovated and opened it to the public in 2007. On June 12, 2009, the McCullough-Price House was added to the National Register of Historic Places, the official listing of America's historic and cultural resources worthy of preservation. The city of Chandler operates the facility, which is located southwest of Chandler Fashion Center at 300 S. Chandler Village Dr.

26. Boston, Massachusetts

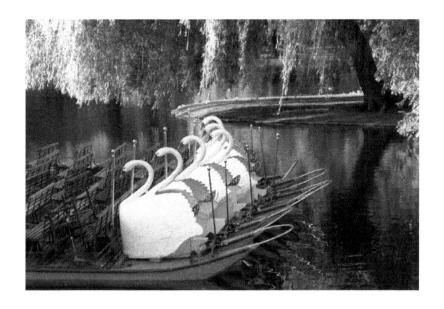

In the core of the city is Boston Normal, America's most seasoned park and the beginning of the Opportunity Trail. In this huge green space, which is abundantly utilized by local people all year, are different landmarks and the Focal Covering Ground of 1756. You can lease skates to use on the Frog Lake from

November through mid-Walk, appreciate the spring blooms and fall foliage colors reflecting in its surface, and in summer, watch adolescents sprinkle about in the swimming pool. Abutting it on the west side of Charles Road, is the 24-section of land Public Nursery, America's most seasoned greenhouse, just as Victorian-style landmarks and sculptures, including an equestrian sculpture of George Washington and mainstream current bronzes of a group of ducks deified in Robert McCloskey's youngsters' book Clear A path for the Ducklings. One of Boston's most notable encounters for all ages is riding around the lake in the

nursery's middle on the acclaimed Swan Boats, first dispatched during the 1870s.

27. Cleveland, Ohio

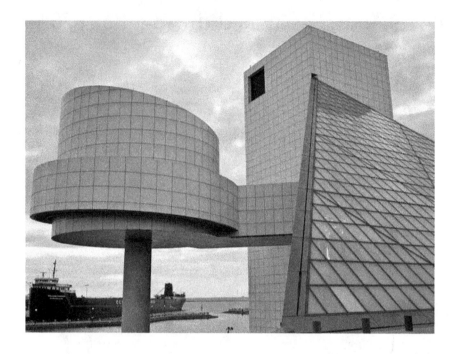

One of the most popular things to do in Cleveland is visit the Rock & Roll Hall of Fame. Designed by I.M. Pei, it is more of an experience than a museum. The history of popular music is spread over six floors in an atmosphere of multimedia exuberance, with such rarities as the

manuscript of *Purple Haze*, written by Jimi Hendrix. It is here that the rock and roll music industry honors its finest entertainers.Music enthusiasts could spend days going through all the museum has to offer, with permanent exhibitions and traveling national and international shows. The eye-catching, state-of-the-art building sits on the shores of Lake Erie. The best way to experience the museum is to start on Level 0, where you find the Hall of Fame Inductees, and work your way to the top.

28. New Orleans, Louisiana

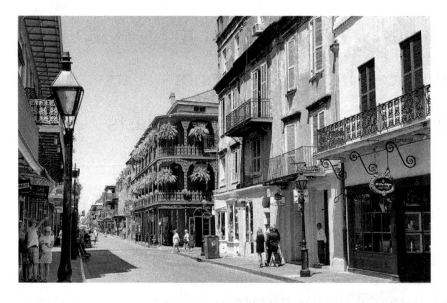

The French Quarter of New Orleans is what most tourists come to see when they visit the city. Set along a bend on the Mississippi River, the main attraction here is the architecture, but it is also a great area for dining and entertainment. The old buildings, some of which date back 300 years, show French influences, with

arcades, wrought iron balconies, red-tiled roofs, and picturesque courtyards. Many of these buildings now contain hotels, restaurants, souvenir shops, galleries, and a profusion of jazz spots with entertainment of varying quality. The most famous street in the French Quarter is **Bourbon Street**, but it is not necessarily the highlight of the area. This street is relatively benign by day but at night transforms into a loud and boisterous pedestrian area that may not always feel safe. **Royal Street** offers a great mix of history, fine cuisine, and unique shopping opportunities, with some higher end stores, galleries, and hotels. One of the

notable buildings on Royal Street is the Court of Two Sisters (1832), now a restaurant known for its jazz brunch. To hear some quality musicians playing traditional jazz music, **Frenchmen Street** is the place to go. Good restaurants can also be found along here, and artists frequent the area. Also, not to be missed in the French Quarter are **Jackson Square** and **St Louis Cathedral**, located just off the waterfront. Buskers, musicians, and artists set up around the square.

29.　　Treasure Island, Florida

Fortune Island's most popular fascination is our sea shore which is comprised of three miles of white sandy sea shore lined by the wonderful Bay of Mexico. You can stroll along the coastline or go for a

walk on the Fortune Island Sea shore Trail. Other Fortune Island exercises incorporate remote oceans fishing contracts, parasailing, boat rentals or essentially laying in the sun on Fortune Island sea shore. The Fortune Island Sea shore Trail is a mile long walkway along the east side of the sea shore. The Fortune Island Sea shore Trail gives simple admittance to the inns, eateries and bars that make up the core of Fortune Island's inn area. Fortune Island's midtown gives a few apparel stores, a pharmacy, banks, alcohol store, flower vendor, cafés, bars and soon another supermarket.

John's Pass Town borders the north finish of Fortune Island while St. Pete Sea shore toward the south has an enormous number of stores, cafés and bars. St. Petersburg is toward the east of Fortune Island and brags of Significant Group Baseball and a bustling midtown region.

30. Park City, Utah

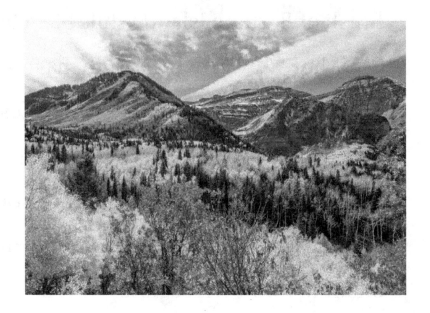

Utah Olympic Park was the home of several events during the 2002 Winter Olympics, and is still an official training site for current and future Olympic athletes. Admission to the park and several of the park's attractions are free, including the Alf Engen Ski Museum, the Eccles Salt

Lake 2002 Olympic Winter Games Museum, the Discovery Zone obstacles course, the Mountain Challenge course and several hiking trails. For a once-in-a-lifetime experience, visitors can ride with a professional driver on the signature Comet Bobsled to feel the same g-force and blazing speed that Olympic competitors enjoy. Other activities – all priced individually – include three levels of climbing and ropes tours, a zip line and a one-hour guided tour that visits the world's highest Nordic ski jumps.

31. Fargo, North Dakota

Across state lines in Moorhead, Minnesota, and a mile walk from downtown Fargo, the Hjemkomst Center is home to the Historical and Cultural Society of Clay County. At the facility, the **Hopperstad Stave Church** replica and the sailable **Hjemkomst Viking Ship** attract the most visits and are both

tangible icons of the Norwegian history of the area.Several permanent and rotating exhibits pertaining to the county are maintained by the historical society. The Hjemkomst Center also hosts various special events throughout the year, including a German Kulturfest and the Scandinavian Hjemkomst & Midwest Viking Festival.

32. Henderson, Nevada

Lake Las Vegas, a man-made lake located in Henderson, stretches for 320 acres. Visitors can utilize the lake for fishing, sailing and swimming. A host of facilities surround the lake as well, including hotels, spas and golf courses. Situated on the shores of the lake, guests find the MonteLago

Village Resort, a Mediterranean-inspired area filled with shops, restaurants, cafes and cobblestone streets. Lake Las Vegas remains a popular destination for business meetings and trade shows. The lake region also plays host to a series of concerts and festivals throughout the year.

33. Garden Grove, California

Atlantis Park is one of the best loved green spots in the city of Garden Grove and is a great place to come if you are travelling with younger visitors.There are a number of grassy knolls in the park as well as play areas for children, and one of the signature attractions in the park is the

dragon slide that takes the form of a large sea serpent.

You will also find a range of concrete animals that children can ride as well as climbers and swings that mean that little ones will never be bored.

34. Scottsdale, Arizona

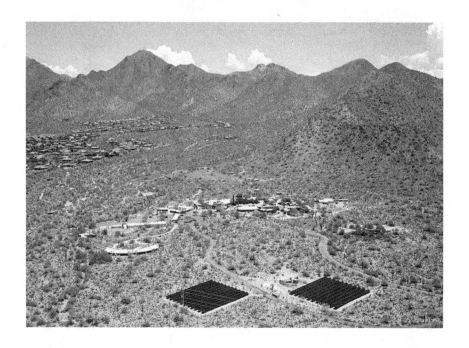

Taliesin West was the winter home of architect Frank Lloyd Wright and is today the headquarters of the **Frank Lloyd Wright Foundation** and the School of Architecture at Taliesin West. Students transition between Taliesin in Wisconsin and Taliesin West in Scottsdale, spending

summers in the north and winters in the south, same as they have been doing for decades. This campus is a fascinating insight into the genius of this famous architect. The buildings have seen ongoing changes and have been restored to their former look and feel. Tours are mandatory if you want to see the property, but guides are passionate about telling the story of the site and provide interesting insights without overwhelming you with details. You can learn about the concepts the architect employed in the buildings and gain a better understanding of what you are seeing on the tour. Taliesin West is a

working architecture school, and you may see students hard at work on their drafting tables if you visit during the winter. The tours take place inside and outside. One of the requirements of students is to create their own simple dwelling out in the desert, where they live while they're here.

35. Estes Park, Colorado

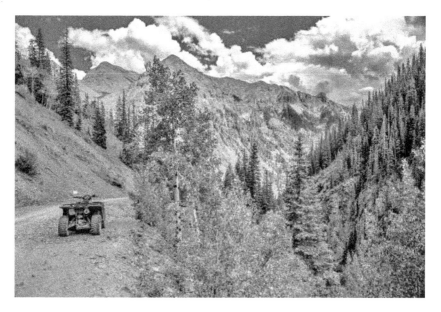

Getting off the road and onto the trail in an ATV is a classic Colorado experience. Estes Park ATV Rentals offers unguided ATV and other vehicle rentals, so you can explore at your own pace and not be hindered by a group - and the views around here are simply stunning.

The ATVs come with maps, helmets, and gas and are already parked on the trail, so you don't need to bring anything except your driver's license. You can book a half- or a full-day rental.

36. Santa Fe, New Mexico

The Historical center of New Mexico Complex houses four galleries that investigate the state's legacy. The New Mexico History Historical center narratives the state's set of experiences from the sixteenth century onwards via

displays that take a gander at the local populaces, colonization, and the manners in which the St Nick Fe Trail formed the state's economy and improvement. The exhibition hall is housed in The Royal residence of Lead representatives, the previous seventeenth century seat of the Spanish government, which is a Public Notable Milestone. Guests can visit this adobe royal residence and see rooms total with period furniture, set up as they would have been during the 1600s. Royal residence Press offers an exceptional opportunity to see live exhibits of the principal print machine in the province of New Mexico. One more fascination at the

complex incorporates the Fight Angelico Chavez History Library, which contains chronicled materials and notable records, and the Photograph Documents, where guests will discover in excess of 750,000 pictures that date back similar to the mid-nineteenth century. The complex likewise has a Local American expressions market that works day by day.

37. Arlington, Virginia

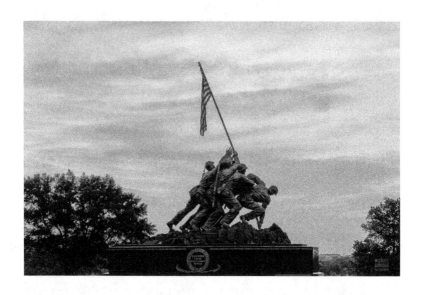

Located at the back entrance to Arlington National Cemetery, the United States Marine Corps War Memorial is a military monument dedicated to the memory of all the members of the United States Marine Corps who have died defending the country since 1775. It is also known as

the Iwo Jima Memorial. The memorial is based on a famous photograph taken by Joe Rosenthal: it depicts the raising of the American flag on Mount Suribachi during the Battle of Iwo Jima in World War II. The massive sculpture was designed by Horace W. Peaslee and the sculpture was completed by Felix de Weldon.

38. Laguna Beach, California

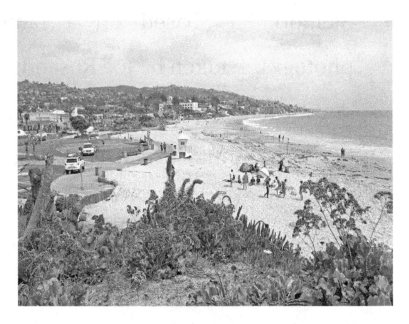

At the intersection of Broadway Street and the Pacific Coast Highway, Main Beach Park is an iconic oceanfront destination complete with sand volleyball nets, a boardwalk, and lifeguards on duty. Popular for celebrities and average tourists alike, the beach area gives a certain vibe

that just feels like Southern California, especially come sunset when the surrounding hillsides full of mansions seem to glow. Riptides are present just offshore, and those interested in swimming should consult with the lifeguards first.A central attraction of Laguna Beach, Main Beach Park branches in either direction for more beautiful sights to see. Plenty of local shops and restaurants of Laguna Beach are inland from the park, including the local favorite, Nick's Laguna Beach.

39. Newport, Rhode Island

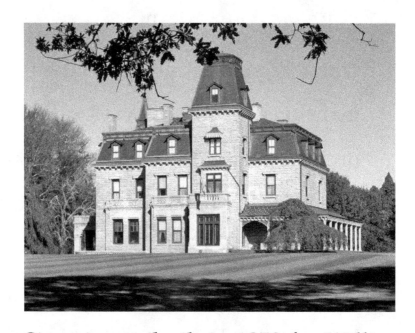

Since it was built in 1852 for William S. Wetmore, Chateau-Sur-Mer has gone through so many reconstructions that today, it is a catalog of nearly all the major Victorian architectural and decorative styles. The Wetmore, whose fortune stemmed from the

China Trade, came early to Newport, when it was the retreat of wealthy families of culture and intellect. Their well-traveled son, who was enthusiastic about the Arts & Crafts movement, hired Richard Morris Hunt to renovate and enlarge the house, and Hunt made it into a showcase for the geometric Eastlake style. The library and dining room bear the stamp of their later Italian designer, and an upstairs sitting room was inspired by Turkish motifs. Perhaps the most remarkable architectural feature is the soaring 45-

foot central hall with stained-glass skylights.

40. Palm Desert, California

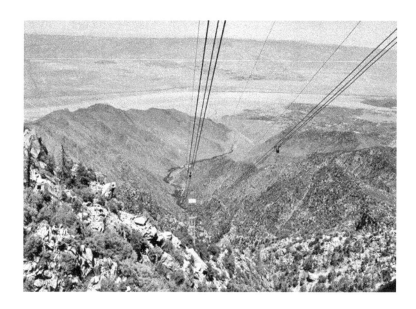

Escape the heat of the desert with a quick ride into the mountains on the Palm Springs Aerial Tramway. Standing on the edge of Palm Springs, Mount San Jacinto rises more than 10,000 feet above the desert floor and can be easily accessed with a ride on the scenic

tramway. The tramway, which opened in 1963, has the world's largest rotating aerial tram cars. The cars are suspended from cables, like a ski lift, and the cables are strung atop metal towers installed on the mountainside. From the top, the view out over the desert is fantastic, and on hot days, the cool air (sometimes 30 to 40 degrees lower than that at the desert floor) can be a refreshing treat. During the winter, there is snow at the top. In less than 10 minutes, the tram will take you up Chino Canyon to an elevation of 8,500 feet. At the top, called the Mountain Station,

there are observation decks, two restaurants, historical displays, and videos on the construction of the tram. From here, 50 miles of hiking trails run through the pine forests of the Santa Rosa and San Jacinto Mountains National Monument.

41.　　Avalon, California

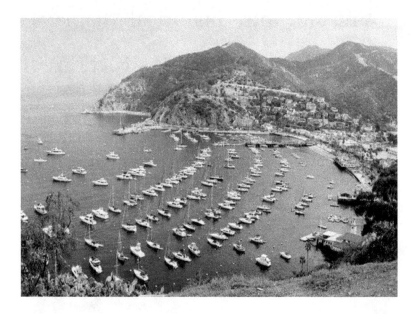

Part of the Channel Islands, Santa Catalina lies about 22 miles southwest of Los Angeles. The island is a popular destination with boaters and day trippers. Avalon is the main population center and where most of the action is centered. On the other end of the island is the much smaller

village of Two Harbors. While most people come to Santa Catalina Island to wander around and enjoy a day of leisure, other popular things to do include glass bottom boat tours, scuba diving, kayaking, and parasailing. You can reach the island by ferry from San Pedro, Long Beach, Newport Beach, and Dana Point.

42. Bozeman, Montana

In Bozeman, it's hard to miss the collegiate "M" posted high onto the ridgeline of **Bridger Canyon**. This 250-foot white-rock letter was built piece by piece by students of Montana State University in 1915 and has since served as a pride point for the University and a symbol for the city. This decorative door hanger at the

mouth of Bridger Canyon is more than just aesthetically pleasing though, and two short hiking trails encourage visitors to hike up and enjoy the view. Two hiking trails lead up to the "M" and adjacent sitting benches. At the trailhead, the steeper half-mile trail forks to the right, and the 1.5-mile switchback trail heads left. Both trails gain 850 feet to reach the "M", which provides straining legs for most average hikers. The "M" is just an introduction to Bozeman hiking endeavors. Alongside many other natural areas in the region, the "M" trail is just the beginning of the 20-mile **Bridger Foothills National Scenic Trail**.

43. La Jolla, California

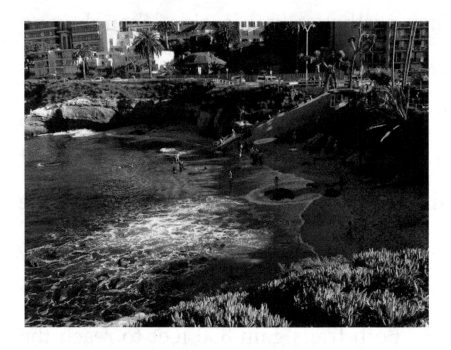

The spectacular La Jolla Underwater Park promises a wonderful adventure and is one of the top La Jolla attractions. Home to a natural marine life preservation and aquatic recreation zone, it sprawls over 6,000 acres of shoreline and shallow tidelands between Ellen Browning

Scripps Park and La Jolla Shores. This incredible ecological reserve hosts two artificial reefs, two underwater canyons, and a vast kelp forest, creating a pristine and protected marine habitat in which a variety of oceanic flora and fauna live. Two sunken artificial reefs attract marine life close to shore and make conditions perfect for swimming and snorkeling in the crisp waters, teeming with beautiful sea creatures. Visitors can take part in a wonderful scuba diving adventure beyond the reefs in the 600-foot deep La Jolla Canyon where migrating whales are often spotted. The La Jolla Underwater Park is a protected zone and fishing is

prohibited. However, other water-based activities such as kayaking, swimming, snorkeling and scuba diving are popular pastimes in the reserve.

44. Portland, Maine

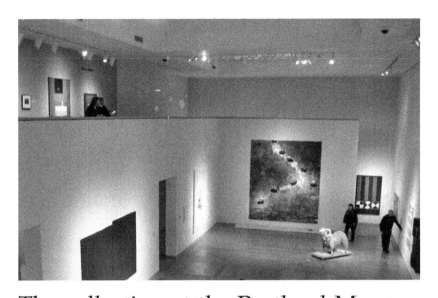

The collection at the Portland Museum of Art features fine and decorative arts dating from the 1700s onward. The museum's collections focus on American and European paintings, and also include a variety of other media like sculpture, pottery, furniture, and other creations, housing more than 18,000 works. This includes 650-plus

works by Winslow Homer, including oil paintings, etchings, and watercolor. Those interested in visiting the nearby Winslow Homer House can purchase tickets at the museum. The museum is also home to the works of major artists including Cassat, Renoir, Monet, Degas, Picasso, and O'Keefe. It also hosts special exhibits, rotates its expansive collection regularly, and features spotlight exhibitions of Maine artists. The museum also offers family events and activities, as well as lectures and curator talks.

45. Biloxi, Mississippi

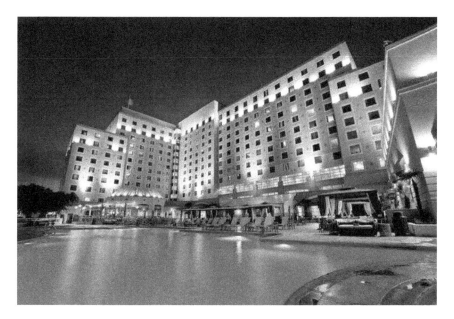

Harrah's has established its brand as a quality casino and accommodation destination, and Harrah's Gulf Coast maintains this reputation in standout fashion. Harrah's Gulf Coast has it all in one package—so much more than just a hotel, the resort includes a large casino, pool and spa, several dining options, and

even a concert venue. Known as the Great Lawn, this venue faces the coastline and provides an all-ages-welcome space for musical performances by well-known acts each Saturday night. In addition to all this, Harrah's also has its own 18-hole golf course, which was designed by legend of the sport Jack Nicklaus.

Canada

Canada is blessed to have some tremendous urban communities spread across its colossal land. Winnipeg is known for its reasonableness; Calgary is famous because it's the nearest significant center to Banff National Park; Ottawa is home to fascinating exhibition halls and the Rideau Canal Yellowknife is the funding to visit to see the Northern Lights.

At that point, you have Vancouver, which is undoubtedly the most exciting city in Canada. It expertly mixes metropolitan city existence with its common environmental factors, so you can go from

the workplace to the mountains in under 60 minutes. Toronto is the fourth most fabulous city in North America, while Montreal and Quebec City bring European appeal to Canada. Regardless of the cityscape, you are looking for, you'll see it in Canada.

1. Quebec City, Quebec

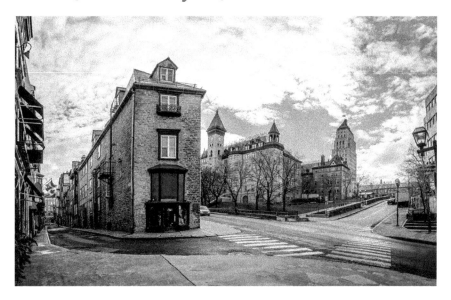

One of the most beautiful cities in the world, Quebec City beckons travelers with historical sites, captivating views, and rich cultural features. Walk along Dufferin Terrace to ogle Château Frontenac and historic battlefields. Architecture and history buffs will love Place Royale, the spot where the city was founded. Have a quiet moment at Jardin

Jeanne d'Arc, a lush park with pristine gardens.

2. Calgary, Alberta

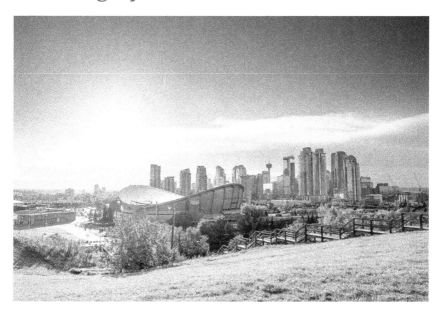

Travelers flock to Calgary for its annual events like the Calgary Stampede, dubbed "The Greatest Outdoor Show on Earth." Whatever your tastes, Calgary has something incredible for you—from the Calgary Folk Music Festival to The Big Taste. Nature is ever-present, too, in the

many city parks and, of course, nearby national park superstar, Banff.

3. Victoria, British Columbia

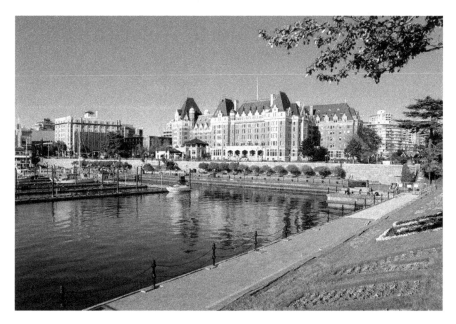

Victoria is a feast of good. The restaurants serve up diverse and delicious choices, the art galleries are filled with interesting works, and the festivals are plentiful and entertaining. Add in easy access to world-renowned Butchart Gardens, as well as many beaches, lakes, and regional parks, and you have a city made for multiple

visits. It comes as no surprise it's rated one of the best cities in North America.

4. Montreal, Quebec

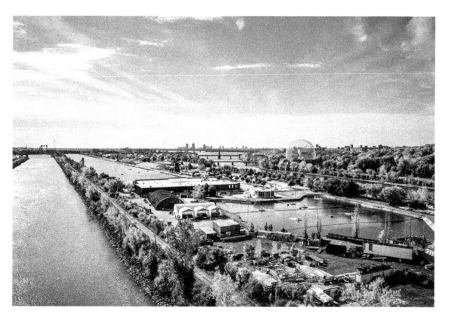

Montreal knows how to rack up the accolades, and its honors include being named a UNESCO City of Design. Experience the goods first-hand when you wander the streets—from historical buildings like the Chalet du Mont Royal to modernist Mies Van der Rohe structures. If you're craving some green space, take a breather in the beautiful Mount Royal Park.

5. Vancouver, British Columbia

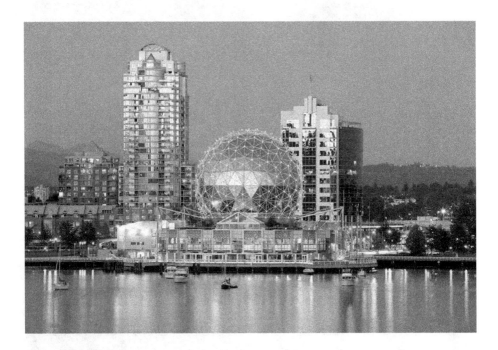

One of the more famous tourist places in North America, Vancouver is a city so enjoyable it takes the awesome majesty of nearby Whistler and Vancouver Island to tempt people away. Nature aside, urban experiences within Vancouver are some of the best in the world, including the food,

art, nightlife, and attractions. Treat yourself at Boulevard Kitchen & Oyster Bar for your first taste, and you'll see what we mean by world-class.

CONCLUSION

Life is full of so many opportunities and adventures, while it depends on the person who is willing to take risk and do so much in life, if you do not take stance right now how you will know the unparalleled beauty around the world, or wander what you have missed in life. Life gives do much chances and it is on us how we take them granted for ourselves. world is full of places and sites which we cannot even imagine in life but are worth seeing and now I have given you the opportunity to see the glimpse of world here and now up to you now, how you enjoy yourselves

in 2021 after so much troubles and tragedies.

CPSIA information can be obtained
at www.ICGtesting.com
Printed in the USA
BVHW051123060321
601818BV00011BA/1530

9 781801 846646